Birding Journal

THROUGH THE SEASONS

D0168631

Adventure Publications, Inc.
Cambridge, Minnesota

by Vanessa Sorensen

Acknowledgements

I would like to thank my husband George Farnsworth for his love and support. His help with content, proofreading, revisions and art direction—not to mention his cooking—made this book possible.

Cover design by Jonathan Norberg

Book design and illustrations by Vanessa Sorensen

10 9 8 7 6 5 4 3

Copyright 2011 by Vanessa Sorensen
Published by Adventure Publications
820 Cleveland Street South
Cambridge, Minnesota 55008
1-800-678-7006
www.adventurepublications.net

ISBN: 978-1-59193-318-2

THIS BOOK BELONGS TO:

DATE:

Table of Contents

Acknowledgements .2

Welcome .5

Spring .7

 March. 8

 April. 18

 May . 28

Summer .39

 June .40

 July .50

 August. .60

Fall .71

 September .72

 October .82

 November .92

Winter . 101

 December. 102

 January. 112

 February . 122

From Year to Year . 132

Key to Illustrations. 140

Birding Life List. 142

About the Author/Illustrator . 148

Welcome to your birding journal!

Keeping a journal is an incredibly rewarding way of keeping track of your bird sightings. This journal is all yours so use it to record whatever interests you most!

One of the things I find most enjoyable about watching birds is recording when I see each species for the first time. By keeping a birding journal I know when to expect my bluebirds to return and when my swallows will head south. It also helps me keep track of who comes to my feeder and what food they like.

At the end of the year when I look back through my journal I am reminded of the joy of seeing each and every bird for the first time.

I hope you will enjoy keeping a birding journal as much as I do.

Happy birding!

To George

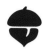

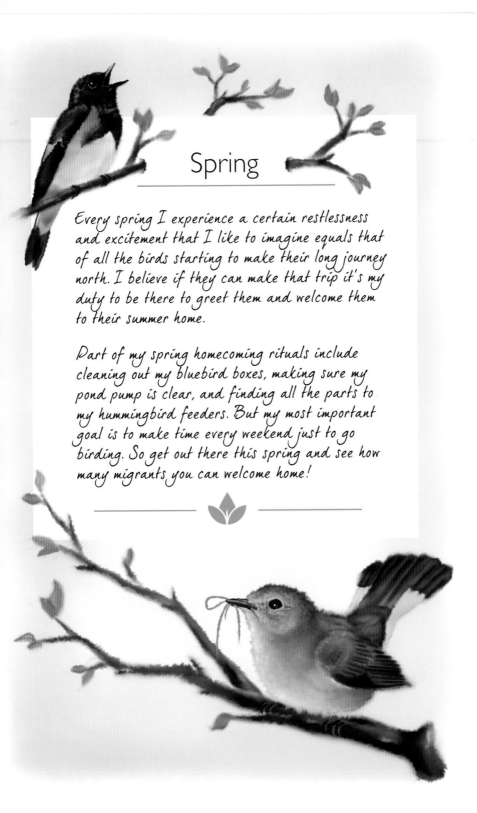

Spring

Every spring I experience a certain restlessness and excitement that I like to imagine equals that of all the birds starting to make their long journey north. I believe if they can make that trip it's my duty to be there to greet them and welcome them to their summer home.

Part of my spring homecoming rituals include cleaning out my bluebird boxes, making sure my pond pump is clear, and finding all the parts to my hummingbird feeders. But my most important goal is to make time every weekend just to go birding. So get out there this spring and see how many migrants you can welcome home!

March

SPECIES: _____
Date: _____
Location: _____
Notes: _____

SPECIES: _____
Date: _____
Location: _____
Notes: _____

SPECIES: _____
Date: _____
Location: _____
Notes: _____

SPECIES: _____
Date: _____
Location: _____
Notes: _____

SPECIES: _____
Date: _____
Location: _____
Notes: _____

SPECIES: _____
Date: _____
Location: _____
Notes: _____

SPECIES: _____
Date: _____
Location: _____
Notes: _____

SPECIES: _____
Date: _____
Location: _____
Notes: _____

SPECIES: _____
Date: _____
Location: _____
Notes: _____

SPECIES: _____
Date: _____
Location: _____
Notes: _____

SPECIES: _____
Date: _____
Location: _____
Notes: _____

SPECIES: _____
Date: _____
Location: _____
Notes: _____

SPECIES: _____
Date: _____
Location: _____
Notes: _____

SPECIES: _____
Date: _____
Location: _____
Notes: _____

SPECIES: _____
Date: _____
Location: _____
Notes: _____

SPECIES: _____
Date: _____
Location: _____
Notes: _____

SPECIES: _____
Date: _____
Location: _____
Notes: _____

SPECIES: _____
Date: _____
Location: _____
Notes: _____

SPECIES: _____

Date: _____

Location: _____

Notes: _____

SPECIES: _____

Date: _____

Location: _____

Notes: _____

SPECIES: _____

Date: _____

Location: _____

Notes: _____

SPECIES: _____

Date: _____

Location: _____

Notes: _____

 ## Build a Nest Box

March is the perfect time to think about building a nesting box for your feathered friends. To attract specific species you will need to know the entry-hole diameter and nesting height that each prefers. Below is a list of species and their preferences.

Species	Hole Diameter (in.)	Nest Box Height (ft.)
Bewick's Wren	1¼	6–10
Bluebirds	1½	5–8
Carolina Wren	1½	6–10
Chickadees	1⅛	6–15
Flycatchers	1½–2	5–20
House Wren	1–1½	5–10
Nuthatches	1–1⅜	6–10
Purple Martin	2¼	12–20
Screech Owl	3	10–30
Tree Swallow	1½	5½–6
Tufted Titmouse	1¼–1½	6–15
Wood Duck	4	6–15

March

SPECIES: _____
Date: _____
Location: _____
Notes: _____

SPECIES: _____
Date: _____
Location: _____
Notes: _____

SPECIES: _____
Date: _____
Location: _____
Notes: _____

SPECIES: _____
Date: _____
Location: _____
Notes: _____

SPECIES: _____
Date: _____
Location: _____
Notes: _____

SPECIES: _____
Date: _____
Location: _____
Notes: _____

SPECIES: _____
Date: _____
Location: _____
Notes: _____

SPECIES: _____
Date: _____
Location: _____
Notes: _____

SPECIES: _____
Date: _____
Location: _____
Notes: _____

SPECIES: _____
Date: _____
Location: _____
Notes: _____

March Birding Trips

Location: _____ Location: _____
Date: _____ Date: _____

_____ _____
_____ _____
_____ _____
_____ _____
_____ _____
_____ _____
_____ _____
_____ _____
_____ _____
_____ _____
_____ _____
_____ _____
_____ _____
_____ _____
_____ _____
_____ _____
_____ _____
_____ _____
_____ _____
_____ _____
_____ _____
_____ _____
_____ _____
_____ _____
_____ _____
_____ _____
_____ _____
_____ _____
_____ _____
_____ _____
_____ _____
_____ _____

Location: _____

Date: _____

 Birdhouses

When thinking about building or purchasing a birdhouse, make sure to consider the type of dwelling and quantity of birds you wish to attract.

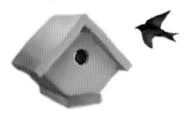

Single Family Living

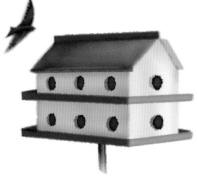

Apartment Living

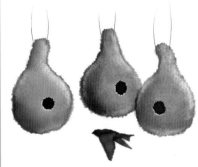

Townhouse Living

Notes

Notes

"Use what talents you possess; the woods would be very silent
if no birds sang there except those that sang best."
- Henry Van Dyke

❧ End-of-the-Month List

April

SPECIES: _____
Date: _____
Location: _____
Notes: _____

SPECIES: _____
Date: _____
Location: _____
Notes: _____

SPECIES: _____
Date: _____
Location: _____
Notes: _____

SPECIES: _____
Date: _____
Location: _____
Notes: _____

SPECIES: _____
Date: _____
Location: _____
Notes: _____

SPECIES: _____
Date: _____
Location: _____
Notes: _____

SPECIES: _____
Date: _____
Location: _____
Notes: _____

SPECIES: _____
Date: _____
Location: _____
Notes: _____

SPECIES: _____
Date: _____
Location: _____
Notes: _____

SPECIES: _____
Date: _____
Location: _____
Notes: _____

SPECIES: _____
Date: _____
Location: _____
Notes: _____

SPECIES: _____
Date: _____
Location: _____
Notes: _____

SPECIES: _____
Date: _____
Location: _____
Notes: _____

SPECIES: _____
Date: _____
Location: _____
Notes: _____

SPECIES: _____
Date: _____
Location: _____
Notes: _____

SPECIES: _____
Date: _____
Location: _____
Notes: _____

SPECIES: _____
Date: _____
Location: _____
Notes: _____

SPECIES: _____
Date: _____
Location: _____
Notes: _____

Early Spring Migrants

BACKYARD

- [] Brown Thrasher
- [] Chipping Sparrow
- [] Eastern Towhee
- [] Gray Catbird
- [] Ruby-throated Hummingbird
- [] White-eyed Vireo

FOREST

- [] Blue-gray Gnatcatcher
- [] Blue-headed Vireo
- [] Broad-winged Hawk
- [] Louisiana Waterthrush
- [] Northern Parula
- [] Pine Warbler
- [] Ruby-crowned Kinglet
- [] Yellow-rumped Warbler
- [] Yellow-throated Warbler

MEADOWS

- [] American Woodcock
- [] Barn Swallow
- [] Eastern Phoebe
- [] Great Egret
- [] Horned Lark
- [] Purple Martin
- [] Sora
- [] Spotted Sandpiper
- [] Tree Swallow
- [] White-crowned Sparrow

SPECIES: _____
Date: _____
Location: _____
Notes: _____

SPECIES: _____
Date: _____
Location: _____
Notes: _____

SPECIES: _____
Date: _____
Location: _____
Notes: _____

SPECIES: _____
Date: _____
Location: _____
Notes: _____

SPECIES: _____
Date: _____
Location: _____
Notes: _____

April

SPECIES: _____
Date: _____
Location: _____
Notes: _____

SPECIES: _____
Date: _____
Location: _____
Notes: _____

SPECIES: _____
Date: _____
Location: _____
Notes: _____

SPECIES: _____
Date: _____
Location: _____
Notes: _____

SPECIES: _____
Date: _____
Location: _____
Notes: _____

SPECIES: _____
Date: _____
Location: _____
Notes: _____

SPECIES: _____
Date: _____
Location: _____
Notes: _____

SPECIES: _____
Date: _____
Location: _____
Notes: _____

SPECIES: _____
Date: _____
Location: _____
Notes: _____

SPECIES: _____
Date: _____
Location: _____
Notes: _____

April Birding Trips

Location: _____ Location: _____
Date: _____ Date: _____

 # Bluebird Boxes

Constructing and maintaining bluebird boxes is a wonderful way to observe bluebirds. Below is a list of things to consider if you are interested in putting up your own bluebird box.

- Use wooden boxes specifically designed for bluebirds and boxes that can be easily cleaned.

- Attach predator guards to your nest boxes.

- Boxes should be mounted 5–8 feet above the ground.

- Choose good habitat. This can be any area with sparse ground cover and scattered trees such as open pastureland or even a golf course. Avoid brushy, heavily wooded areas, areas where house sparrows are abundant (near barns or houses), and areas of pesticide use.

- Face boxes towards open areas, preferably away from prevailing winds.

- Keep boxes at least 300 feet apart to reduce competition.

- Monitor your boxes frequently but be sure not to disturb a brooding female for one week after hatching (eggs take about two weeks to hatch). Also do not check nest boxes in cold or wet weather.

- Remove house sparrow nests immediately when found.

- Once bluebirds have fledged, some people suggest removing the old nest to get rid of nest parasites and to stimulate re-nesting.

- Clean and repair boxes in the fall (and again in the spring) with a wire brush and mild bleach solution.

- Leave boxes out during the winter. They provide roosting sites and protection from the weather.

- To attract bluebirds to your boxes try offering mealworms, putting out a birdbath or planting native berry-producing plants nearby.

Notes

"The bluebird carries the sky on his back."
—Henry David Thoreau

Notes

Birding Contests

*Participating in a birdathon is one of the most fun
ways to raise funding for conservation. Perhaps the
most famous competition is "The World Series of
Birding" in New Jersey in May. Participants attempt
to identify the greatest number of species over a
24-hour period and solicit pledges for each species.
Birdathons take place throughout the country so
check with your local birding group for opportunities.*

April

End-of-the-Month List

7

May

SPECIES: _____
Date: _____
Location: _____
Notes: _____

SPECIES: _____
Date: _____
Location: _____
Notes: _____

SPECIES: _____
Date: _____
Location: _____
Notes: _____

SPECIES: _____
Date: _____
Location: _____
Notes: _____

SPECIES: _____
Date: _____
Location: _____
Notes: _____

SPECIES: _____
Date: _____
Location: _____
Notes: _____

SPECIES: _____
Date: _____
Location: _____
Notes: _____

SPECIES: _____
Date: _____
Location: _____
Notes: _____

SPECIES: _____
Date: _____
Location: _____
Notes: _____

SPECIES: _____
Date: _____
Location: _____
Notes: _____

SPECIES: _____
Date: _____
Location: _____
Notes: _____

SPECIES: _____
Date: _____
Location: _____
Notes: _____

SPECIES: _____
Date: _____
Location: _____
Notes: _____

SPECIES: _____
Date: _____
Location: _____
Notes: _____

SPECIES: _____
Date: _____
Location: _____
Notes: _____

SPECIES: _____
Date: _____
Location: _____
Notes: _____

SPECIES: _____
Date: _____
Location: _____
Notes: _____

SPECIES: _____
Date: _____
Location: _____
Notes: _____

Spring Migration Hotspots

Throughout the country there are certain locations where the topography acts as a natural "funnel" for migrating birds. In the spring it is well worth the trip to see the amazing number and variety of birds that visit these locations. The following is a list of some of these spring migration hotspots.

Copper River Delta, AK
Monterey Bay, CA
Point Reyes, CA
Pawnee Grasslands, CO
Delaware Bay, DE
Everglades, FL
Muscatatuck NWR, IN
Quivira NWR, KS
Grand Isle, LA
Newburyport, MA
Freezeout Lake, MT
Mattamuskeet NWR, NC
Cape May, NJ
Crane Creek, OH
Presque Isle, PA
Union County State Pk, SD
High Island, TX
Rockport, TX

SPECIES: _____
Date: _____
Location: _____
Notes: _____

SPECIES: _____
Date: _____
Location: _____
Notes: _____

SPECIES: _____
Date: _____
Location: _____
Notes: _____

SPECIES: _____
Date: _____
Location: _____
Notes: _____

SPECIES: _____
Date: _____
Location: _____
Notes: _____

May

SPECIES: _____
Date: _____
Location: _____
Notes: _____

SPECIES: _____
Date: _____
Location: _____
Notes: _____

SPECIES: _____
Date: _____
Location: _____
Notes: _____

SPECIES: _____
Date: _____
Location: _____
Notes: _____

SPECIES: _____
Date: _____
Location: _____
Notes: _____

SPECIES: _____
Date: _____
Location: _____
Notes: _____

SPECIES: _____
Date: _____
Location: _____
Notes: _____

SPECIES: _____
Date: _____
Location: _____
Notes: _____

SPECIES: _____
Date: _____
Location: _____
Notes: _____

SPECIES: _____
Date: _____
Location: _____
Notes: _____

 # May Birding Trips

Location: _____ Location: _____
Date: _____ Date: _____

_____ _____
_____ _____
_____ _____
_____ _____
_____ _____
_____ _____
_____ _____
_____ _____
_____ _____
_____ _____
_____ _____
_____ _____
_____ _____
_____ _____
_____ _____
_____ _____
_____ _____
_____ _____
_____ _____
_____ _____
_____ _____
_____ _____
_____ _____
_____ _____
_____ _____
_____ _____
_____ _____
_____ _____
_____ _____
_____ _____

Location: _____

Date: _____

 ## Nest Types

Not all birds build nests, but for those that do, the type of nest depends on habitat, climate, and the condition of the young when hatched. Below is a list of nest types and some examples of species that build each type.

Burrows
 kingfishers

Cavities
 most owls
 woodpeckers

Open cup nests
 cuckoos
 doves
 hummingbirds
 most songbirds

Mounds
 flamingos
 grebes
 loons

Platforms
 eagles
 herons
 osprey

Pendants
 orioles

Scrapes
 gulls
 nighthawks
 terns
 vultures

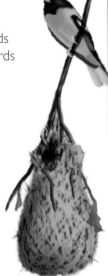

Notes

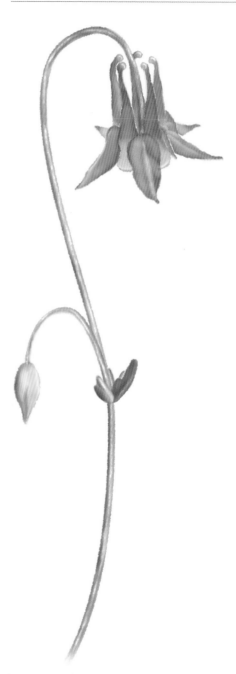

May

 "A bird doesn't sing because it has an answer, it sings because it has a song."

— Lou Holtz

Notes

International Migratory Bird Day (IMBD)

IMBD is a holiday dedicated to celebrating and raising awareness about the amazing event of bird migration! In the U.S. and Canada, IMBD is celebrated on the 2nd Saturday in May and in most Latin American countries, the 2nd Saturday in October. Dates of events can vary so check with your local birding groups for dates and activities.

May

🌿 End-of-the-Month List

May

End-of-the-Month List

Summer

One of my favorite things to do in the summer is to wake up when the sun is just creeping above the horizon and slip outside for a nice long walk before breakfast. The birds are quite active at this time of day but my growling stomach usually drives me home. By midday the heat dampens all sound except the chirping crickets and the distant rumble of an airplane.

Aside from my walks, I also love to watch my water fountains and bird baths in the summer. The heat and dry conditions bring many interesting birds in for a drink and bath. There is nothing better than sitting on the porch sipping a cool lemonade while watching a flock of cedar waxwings taking their turns at the bath. We all leave refreshed and ready for a nap.

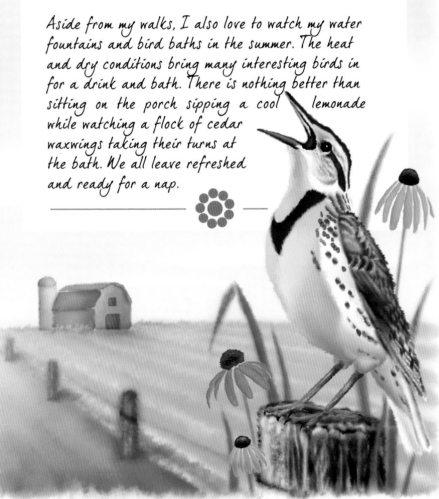

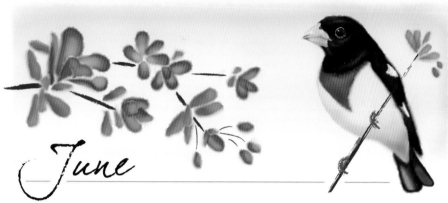

June

SPECIES: _____
Date: _____
Location: _____
Notes: _____

SPECIES: _____
Date: _____
Location: _____
Notes: _____

SPECIES: _____
Date: _____
Location: _____
Notes: _____

SPECIES: _____
Date: _____
Location: _____
Notes: _____

SPECIES: _____
Date: _____
Location: _____
Notes: _____

SPECIES: _____
Date: _____
Location: _____
Notes: _____

SPECIES: _____
Date: _____
Location: _____
Notes: _____

SPECIES: _____
Date: _____
Location: _____
Notes: _____

SPECIES: _____
Date: _____
Location: _____
Notes: _____

SPECIES: _____
Date: _____
Location: _____
Notes: _____

SPECIES: _____
Date: _____
Location: _____
Notes: _____

SPECIES: _____
Date: _____
Location: _____
Notes: _____

SPECIES: _____
Date: _____
Location: _____
Notes: _____

SPECIES: _____
Date: _____
Location: _____
Notes: _____

SPECIES: _____
Date: _____
Location: _____
Notes: _____

SPECIES: _____
Date: _____
Location: _____
Notes: _____

SPECIES: _____
Date: _____
Location: _____
Notes: _____

SPECIES: _____
Date: _____
Location: _____
Notes: _____

Bird Songs

When out birding we often hear the birds we are looking for before we see them. Mnemonics are a great way to help remember each species' songs. Below is a list of common mnemonics.

American Robin
 Cheer-up; cheer-a-lee;
 cheer-ee-o, whinny

Barred Owl
 Who-cooks-for-you;
 who-cooks-for-you-all?

Brown Thrasher
 Drop it, drop it,
 pick it up, pick it up,
 cover it up, cover it up

Indigo Bunting
 Fire, fire! Where, where?
 Here, here! See it, see it?

Song Sparrow
 Maids, maids, maids,
 put on your tea
 kettle-ettle-ettle

Warbling Vireo
 If I sees you; I will seize
 you; and I'll squeeze you
 till you squeak

White-throated Sparrow
 Poor-Sam-Peabody-
 Peabody-Peabody

Yellow Warbler
 Sweet, sweet, sweet,
 I'm so sweet

SPECIES: _____
Date: _____
Location: _____
Notes: _____

SPECIES: _____
Date: _____
Location: _____
Notes: _____

SPECIES: _____
Date: _____
Location: _____
Notes: _____

SPECIES: _____
Date: _____
Location: _____
Notes: _____

SPECIES: _____
Date: _____
Location: _____
Notes: _____

SPECIES: _____
Date: _____
Location: _____
Notes: _____

SPECIES: _____
Date: _____
Location: _____
Notes: _____

SPECIES: _____
Date: _____
Location: _____
Notes: _____

SPECIES: _____
Date: _____
Location: _____
Notes: _____

SPECIES: _____
Date: _____
Location: _____
Notes: _____

SPECIES: _____
Date: _____
Location: _____
Notes: _____

SPECIES: _____
Date: _____
Location: _____
Notes: _____

SPECIES: _____
Date: _____
Location: _____
Notes: _____

SPECIES: _____
Date: _____
Location: _____
Notes: _____

SPECIES: _____
Date: _____
Location: _____
Notes: _____

 # June Birding Trips

Location: _____ Location: _____
Date: _____ Date: _____

 ## Chick Development

Songbirds usually have altricial chicks that develop very fast, taking anywhere from 10-18 days to fledge. The illustrations below show three stages of chickadee development.
(Drawings are not to scale.)

Day 1

- eyes are closed
- no feathers, light down
- no ear holes yet
- pink skin
- around ¾" in length

Day 6

- eye slits
- feather sheaths
- ear holes
- skin turning darker
- around 1½" in length

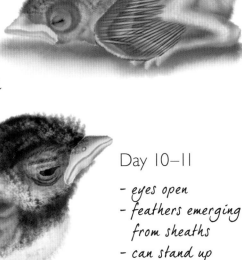

Day 10-11

- eyes open
- feathers emerging
 from sheaths
- can stand up
- around 2" in length

Notes

"And the day came when the risk to remain tight in a bud was more painful than the risk it took to blossom."

— Anaïs Nin

Notes

Citizen Science

You can help bird conservation efforts by helping collect data that scientists use to determine population trends. Below are just a few programs that need your help.

- *Project FeederWatch*
- *Breeding Bird Survey*
- *Christmas Bird Count*
- *Great Backyard Bird Count*

- *eBird*
- *Breeding Bird Atlas*
- *NestWatch*
- *NestCams*

End-of-the-Month List

July

SPECIES: _____
Date: _____
Location: _____
Notes: _____

SPECIES: _____
Date: _____
Location: _____
Notes: _____

SPECIES: _____
Date: _____
Location: _____
Notes: _____

SPECIES: _____
Date: _____
Location: _____
Notes: _____

SPECIES: _____
Date: _____
Location: _____
Notes: _____

SPECIES: _____
Date: _____
Location: _____
Notes: _____

SPECIES: _____
Date: _____
Location: _____
Notes: _____

SPECIES: _____
Date: _____
Location: _____
Notes: _____

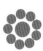

SPECIES: _____
Date: _____
Location: _____
Notes: _____

SPECIES: _____
Date: _____
Location: _____
Notes: _____

SPECIES: _____
Date: _____
Location: _____
Notes: _____

SPECIES: _____
Date: _____
Location: _____
Notes: _____

SPECIES: _____
Date: _____
Location: _____
Notes: _____

SPECIES: _____
Date: _____
Location: _____
Notes: _____

SPECIES: _____
Date: _____
Location: _____
Notes: _____

SPECIES: _____
Date: _____
Location: _____
Notes: _____

SPECIES: _____
Date: _____
Location: _____
Notes: _____

SPECIES: _____
Date: _____
Location: _____
Notes: _____

Feeding Hummingbirds

Plants to attract hummingbirds

Beebalm
Butterflybush
Cardinal flower
Columbine
Coral Bells
Foxglove
Hollyhock
Hosta
Lantana
Lupine
Mimosa
Morning Glory
Penstemon
Phlox
Red-hot Poker
Rose of Sharon
Salvia
Trumpet Vine
Turk's Cap
Yucca

Sugar Water

Boil ¼ cup sugar in 1 cup of water. Let cool before filling feeder. Be sure to change the water every few days!

SPECIES: _____
Date: _____
Location:_____
Notes: _____

SPECIES: _____
Date: _____
Location:_____
Notes: _____

SPECIES: _____
Date: _____
Location:_____
Notes: _____

SPECIES: _____
Date: _____
Location:_____
Notes: _____

SPECIES: _____
Date: _____
Location: _____
Notes: _____

SPECIES: _____
Date: _____
Location: _____
Notes: _____

SPECIES: _____
Date: _____
Location: _____
Notes: _____

SPECIES: _____
Date: _____
Location: _____
Notes: _____

SPECIES: _____
Date: _____
Location:_____
Notes: _____

SPECIES: _____
Date: _____
Location: _____
Notes: _____

SPECIES: _____
Date: _____
Location: _____
Notes: _____

"Like the hummingbird sipping nectar from every flower, I fly joyfully through my days, seeing beauty in everything."
- Amethyst Wyldfyre

 July Birding Trips

Location:_____ Location:_____
Date: _____ Date: _____
_____ _____
_____ _____
_____ _____
_____ _____
_____ _____
_____ _____
_____ _____
_____ _____
_____ _____
_____ _____
_____ _____
_____ _____
_____ _____
_____ _____
_____ _____
_____ _____
_____ _____
_____ _____
_____ _____
_____ _____
_____ _____
_____ _____
_____ _____
_____ _____
_____ _____
_____ _____
_____ _____

Location: _____

Date: _____

Birding by Boat

Birding by boat is a great way to get close-up views of pelagic birds. It's an amazing experience to watch an albatross soaring above or a storm petrel walking on water.

The following is a list of well-known pelagic birding departure locations and destinations.

Cape Hatteras, NC
Monterey Bay, CA
Gray's Harbor, WA
Machias Seal Island, ME
Perpetua Bank, OR
Aleutian Islands, AK
South Padre Island, TX
Newburyport, MA
Dauphin Island, AL
Dry Tortugas, FL
Pt. Loma, CA
Bar Harbor, ME
Cox's Ledge, RI

Notes

Notes

 "I'm youth, I'm joy, I'm a little bird that has broken out of the egg."

- James M. Barrie

End-of-the-Month List

August

SPECIES: _____
Date: _____
Location: _____
Notes: _____

SPECIES: _____
Date: _____
Location: _____
Notes: _____

SPECIES: _____
Date: _____
Location: _____
Notes: _____

SPECIES: _____
Date: _____
Location: _____
Notes: _____

SPECIES: _____
Date: _____
Location: _____
Notes: _____

SPECIES: _____
Date: _____
Location: _____
Notes: _____

SPECIES: _____
Date: _____
Location: _____
Notes: _____

SPECIES: _____
Date: _____
Location: _____
Notes: _____

SPECIES: _____
Date: _____
Location: _____
Notes: _____

SPECIES: _____
Date: _____
Location: _____
Notes: _____

SPECIES: _____
Date: _____
Location: _____
Notes: _____

SPECIES: _____
Date: _____
Location: _____
Notes: _____

SPECIES: _____
Date: _____
Location: _____
Notes: _____

SPECIES: _____
Date: _____
Location: _____
Notes: _____

SPECIES: _____
Date: _____
Location: _____
Notes: _____

SPECIES: _____
Date: _____
Location: _____
Notes: _____

SPECIES: _____
Date: _____
Location: _____
Notes: _____

SPECIES: _____
Date: _____
Location: _____
Notes: _____

Water Features

If you are interested in attracting birds to your yard, a water source is essential. Water features not only provide birds a much needed source for drinking water, but also a way to keep clean and cool. Consider the following options when installing a water source:

Bird Baths

Bird baths come in many shapes and sizes. Just be sure the water isn't too deep (no more than 3"). A shallow end can also be created by adding rocks. Also, be sure to refresh water several times a week.

Drip Devices

A drip device is an excellent way to draw birds to a silent bird bath. Drip devices are available commercially or you can make your own by suspending a bucket with a tiny hole above the bath.

Misters

To attract hummingbirds and warblers, consider installing a light misting water source.

Waterfall/Pond

If space allows, a waterfall or pond is a great way to draw not only songbirds, but larger wading birds.

SPECIES: _____
Date: _____
Location: _____
Notes: _____

SPECIES: _____
Date: _____
Location: _____
Notes: _____

SPECIES: _____
Date: _____
Location: _____
Notes: _____

SPECIES: _____
Date: _____
Location: _____
Notes: _____

SPECIES: _____
Date: _____
Location: _____
Notes: _____

August

SPECIES: _____
Date: _____
Location: _____
Notes: _____

SPECIES: _____
Date: _____
Location: _____
Notes: _____

SPECIES: _____
Date: _____
Location: _____
Notes: _____

SPECIES: _____
Date: _____
Location: _____
Notes: _____

SPECIES: _____
Date: _____
Location: _____
Notes: _____

SPECIES: _____
Date: _____
Location: _____
Notes: _____

SPECIES: _____
Date: _____
Location: _____
Notes: _____

SPECIES: _____
Date: _____
Location: _____
Notes: _____

SPECIES: _____
Date: _____
Location: _____
Notes: _____

SPECIES: _____
Date: _____
Location: _____
Notes: _____

August Birding Trips

Location:_____ Location:_____
Date: _____ Date: _____

Molting

Feathers are lifeless structures that cannot heal on their own (like our fingernails) and must be replaced when worn or damaged. This process of replacing all or part of a bird's feathers is called molting.

The type of molt depends on age, sex, season and habitat and can make identification difficult. The terminology to describe all the different stages of molts can get complicated, but the most common are described below.

Basic Plumage—the covering of feathers that occurs after the breeding season. Commonly this is a duller, more drab plumage than the breeding season plumage.

Scarlet Tanager

Basic Plumage

Alternate (or Nuptial) Plumage—this is the breeding season plumage and is typically the brighter, more colorful plumage used to attract a mate.

Prealternate Molt

Juvenile Plumage—the unique covering of feathers before a bird reaches adulthood

Alternate Plumage

Supplemental Plumage—any plumage in addition to the basic or alternate plumage

The molts that precede these plumages may then be described as prebasic, prealternate, prejuvenile, or presupplemental.

Notes

August

"Adopt the pace of nature: her secret is patience."
 - Ralph Waldo Emerson

Notes

August

End-of-the-Month List

August

End-of-the-Month List

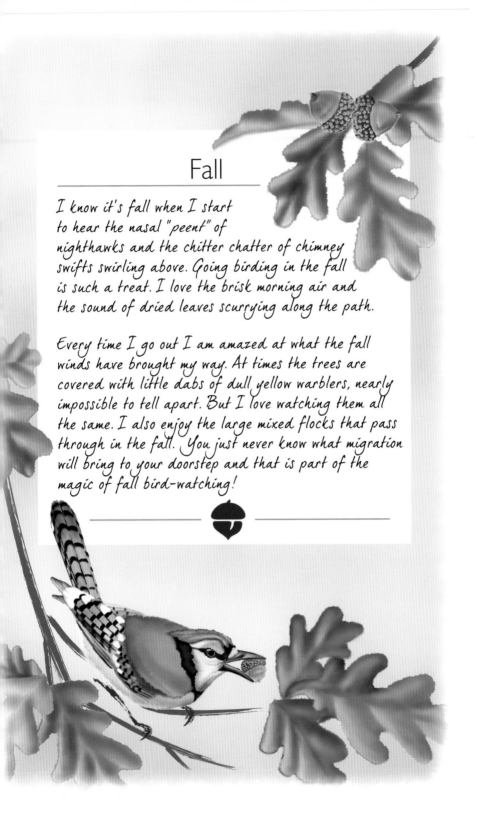

Fall

I know it's fall when I start
to hear the nasal "peent" of
nighthawks and the chitter chatter of chimney
swifts swirling above. Going birding in the fall
is such a treat. I love the brisk morning air and
the sound of dried leaves scurrying along the path.

Every time I go out I am amazed at what the fall
winds have brought my way. At times the trees are
covered with little dabs of dull yellow warblers, nearly
impossible to tell apart. But I love watching them all
the same. I also enjoy the large mixed flocks that pass
through in the fall. You just never know what migration
will bring to your doorstep and that is part of the
magic of fall bird-watching!

September

SPECIES: _____
Date: _____
Location: _____
Notes: _____

SPECIES: _____
Date: _____
Location: _____
Notes: _____

SPECIES: _____
Date: _____
Location: _____
Notes: _____

SPECIES: _____
Date: _____
Location: _____
Notes: _____

SPECIES: _____
Date: _____
Location: _____
Notes: _____

SPECIES: _____
Date: _____
Location: _____
Notes: _____

SPECIES: _____
Date: _____
Location: _____
Notes: _____

SPECIES: _____
Date: _____
Location: _____
Notes: _____

SPECIES: _____
Date: _____
Location: _____
Notes: _____

SPECIES: _____
Date: _____
Location: _____
Notes: _____

SPECIES: _____
Date: _____
Location: _____
Notes: _____

SPECIES: _____
Date: _____
Location: _____
Notes: _____

SPECIES: _____
Date: _____
Location: _____
Notes: _____

SPECIES: _____
Date: _____
Location: _____
Notes: _____

SPECIES: _____
Date: _____
Location: _____
Notes: _____

SPECIES: _____
Date: _____
Location: _____
Notes: _____

SPECIES: _____
Date: _____
Location: _____
Notes: _____

SPECIES: _____
Date: _____
Location: _____
Notes: _____

Common Shorebird Migrants

- American Avocet
- American Golden Plover
- Black-bellied Plover
- Black-necked Stilt
- Buff-breasted Sandpiper
- Dunlin
- Greater Yellowlegs
- Least Sandpiper
- Lesser Yellowlegs
- Long-billed Curlew
- Long-billed Dowitcher
- Marbled Godwit
- Purple Sandpiper
- Red Knot
- Ruddy Turnstone
- Sanderling
- Semipalmated Plover
- Semipalmated Sandpiper
- Short-billed Dowitcher
- Snowy Plover
- Solitary Sandpiper
- Spotted Sandpiper
- Western Sandpiper
- White-rumped Sandpiper
- Willet
- Wilson's Phalarope
- Wilson's Snipe
- Wimbrel

SPECIES: _____
Date: _____
Location: _____
Notes: _____

SPECIES: _____
Date: _____
Location: _____
Notes: _____

SPECIES: _____
Date: _____
Location: _____
Notes: _____

SPECIES: _____
Date: _____
Location: _____
Notes: _____

SPECIES: _____
Date: _____
Location: _____
Notes: _____

SPECIES: _____
Date: _____
Location: _____
Notes: _____

SPECIES: _____
Date: _____
Location: _____
Notes: _____

SPECIES: _____
Date: _____
Location: _____
Notes: _____

SPECIES: _____
Date: _____
Location: _____
Notes: _____

SPECIES: _____
Date: _____
Location: _____
Notes: _____

SPECIES: _____
Date: _____
Location: _____
Notes: _____

SPECIES: _____
Date: _____
Location: _____
Notes: _____

SPECIES: _____
Date: _____
Location: _____
Notes: _____

SPECIES: _____
Date: _____
Location: _____
Notes: _____

SPECIES: _____
Date: _____
Location: _____
Notes: _____

September Birding Trips

Location:_____

Date:_____

Location:_____

Date:_____

Location:

Date:

 Nuts for Birds

Throughout the fall and winter, nuts provide an important source of food for birds that is high in fat, carbohydrates and protein. When landscaping your yard consider planting nut-bearing trees.

Birds that consume nuts

Cardinals

Chickadees

Grosbeaks

Grouse

Jays

Nuthatches

Quail

Wild Turkeys

Woodpeckers

Nut-bearing trees important for birds

American Beech

Birches

Bladdernut

Butternut

Chestnut

Hazelnuts

Hickories

Oaks

Pecans

Pines

Pignut hickory

Notes

 "Delicious autumn! My very soul is wedded to it, and if I were a bird I would fly about the earth seeking the successive autumns."

– George Eliot

September

Notes

End-of-the-Month List

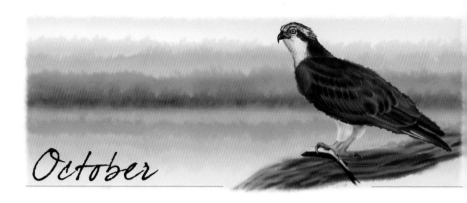

October

SPECIES: _____
Date: _____
Location: _____
Notes: _____

SPECIES: _____
Date: _____
Location: _____
Notes: _____

SPECIES: _____
Date: _____
Location: _____
Notes: _____

SPECIES: _____
Date: _____
Location: _____
Notes: _____

SPECIES: _____
Date: _____
Location: _____
Notes: _____

SPECIES: _____
Date: _____
Location: _____
Notes: _____

SPECIES: _____
Date: _____
Location: _____
Notes: _____

SPECIES: _____
Date: _____
Location: _____
Notes: _____

SPECIES: _____
Date: _____
Location: _____
Notes: _____

SPECIES: _____
Date: _____
Location: _____
Notes: _____

SPECIES: _____
Date: _____
Location: _____
Notes: _____

SPECIES: _____
Date: _____
Location: _____
Notes: _____

SPECIES: _____
Date: _____
Location: _____
Notes: _____

SPECIES: _____
Date: _____
Location: _____
Notes: _____

SPECIES: _____
Date: _____
Location: _____
Notes: _____

SPECIES: _____
Date: _____
Location: _____
Notes: _____

SPECIES: _____
Date: _____
Location: _____
Notes: _____

SPECIES: _____
Date: _____
Location: _____
Notes: _____

Confusing Fall Warblers

- ☐ Bay-breasted Warbler
- ☐ Blackburnian Warbler
- ☐ Blackpoll Warbler
- ☐ Black-throated Blue Warbler
- ☐ Black-throated Green Warbler
- ☐ Canada Warbler
- ☐ Cape May Warbler
- ☐ Chestnut-sided Warbler
- ☐ Common Yellowthroat
- ☐ Connecticut Warbler
- ☐ Hooded Warbler
- ☐ Louisiana Waterthrush
- ☐ Magnolia Warbler
- ☐ Mourning Warbler
- ☐ Nashville Warbler
- ☐ Northern Parula
- ☐ Northern Waterthrush
- ☐ Orange-crowned Warbler
- ☐ Ovenbird
- ☐ Palm Warbler
- ☐ Pine Warbler
- ☐ Prairie Warbler
- ☐ Prothonotary Warbler
- ☐ Swainson's Warbler
- ☐ Tennessee Warbler
- ☐ Wilson's Warbler
- ☐ Yellow Warbler
- ☐ Yellow-rumped Warbler

SPECIES: _____
Date: _____
Location: _____
Notes: _____

SPECIES: _____
Date: _____
Location: _____
Notes: _____

SPECIES: _____
Date: _____
Location: _____
Notes: _____

SPECIES: _____
Date: _____
Location: _____
Notes: _____

SPECIES: _____
Date: _____
Location: _____
Notes: _____

October

SPECIES: _____
Date: _____
Location:_____
Notes: _____

SPECIES: _____
Date: _____
Location:_____
Notes: _____

SPECIES: _____
Date: _____
Location:_____
Notes: _____

SPECIES: _____
Date: _____
Location:_____
Notes: _____

SPECIES: _____
Date: _____
Location:_____
Notes: _____

SPECIES: _____
Date: _____
Location:_____
Notes: _____

SPECIES: _____
Date: _____
Location:_____
Notes: _____

SPECIES: _____
Date: _____
Location:_____
Notes: _____

SPECIES: _____
Date: _____
Location:_____
Notes: _____

SPECIES: _____
Date: _____
Location:_____
Notes: _____

October Birding Trips

Location:_____ Location:_____
Date: _____ Date: _____

_____ _____
_____ _____
_____ _____
_____ _____
_____ _____
_____ _____
_____ _____
_____ _____
_____ _____
_____ _____
_____ _____
_____ _____
_____ _____
_____ _____
_____ _____
_____ _____
_____ _____
_____ _____
_____ _____
_____ _____
_____ _____
_____ _____
_____ _____
_____ _____
_____ _____
_____ _____
_____ _____
_____ _____
_____ _____

Location:

Date:

Sites for Hawk-watching

Each fall thousands of hawks head south to their wintering grounds and it is truly a sight to see. Below is a list of a few of the many spectacular hawk-watching locations throughout the country.

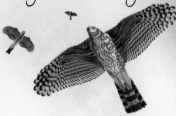

Lipan & Yaki Points, AZ
Golden Gate, CA
Dinosaur Ridge, CO
Marathon, FL
Turkey Point, MD
Cadillac Mtn, ME
Hawk Ridge, MN
Bridger Mtns, MT
Cape May, NJ
Chimney Rock, NJ
Manzano & Sandia Mtns, NM
Goshute Mtns, NV
Bonney Butte, OR
Hawk Mountain, PA
Smith Point, TX
Corpus Christi, TX
Chelan Ridge, WA
Commissary Ridge, WY

Notes

 "Autumn is a second spring when every leaf is a flower."
— Albert Camus

Notes

End-of-the-Month List

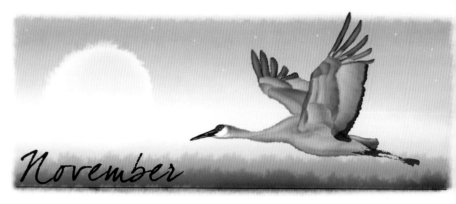

November

SPECIES: _____
Date: _____
Location: _____
Notes: _____

SPECIES: _____
Date: _____
Location: _____
Notes: _____

SPECIES: _____
Date: _____
Location: _____
Notes: _____

SPECIES: _____
Date: _____
Location: _____
Notes: _____

SPECIES: _____
Date: _____
Location: _____
Notes: _____

SPECIES: _____
Date: _____
Location: _____
Notes: _____

SPECIES: _____
Date: _____
Location: _____
Notes: _____

SPECIES: _____
Date: _____
Location: _____
Notes: _____

SPECIES: _____
Date: _____
Location: _____
Notes: _____

SPECIES: _____
Date: _____
Location: _____
Notes: _____

SPECIES: _____
Date: _____
Location: _____
Notes: _____

SPECIES: _____
Date: _____
Location: _____
Notes: _____

SPECIES: _____
Date: _____
Location: _____
Notes: _____

SPECIES: _____
Date: _____
Location: _____
Notes: _____

SPECIES: _____
Date: _____
Location: _____
Notes: _____

SPECIES: _____
Date: _____
Location: _____
Notes: _____

SPECIES: _____
Date: _____
Location: _____
Notes: _____

SPECIES: _____
Date: _____
Location: _____
Notes: _____

SPECIES: _____ SPECIES: _____
Date: _____ Date: _____
Location: _____ Location: _____
Notes: _____ Notes: _____
_____ _____
_____ _____
_____ _____

SPECIES: _____ SPECIES: _____
Date: _____ Date: _____
Location: _____ Location: _____
Notes: _____ Notes: _____
_____ _____
_____ _____
_____ _____

 Migration Distance

The distance a bird migrates varies by species and by individual birds. The list to the right shows how widely migration distances can vary.

Approximate annual round-trip mileage for each species

Arctic Tern	22,000
Franklin's Gull	17,000
Red Knot	16,000
Swainson's Hawk	15,000
Purple Martin	8,000
Blackpoll Warbler	6,000
Ruby-throated Hummingbird	5,000
Wood Thrush	4,000
Redhead	3,500
Whooping Crane	2,500
Cattle Egret	1,500
Yellow-bellied Sapsucker	800
Northern Mockingbird	0

November

SPECIES: _____
Date: _____
Location:_____
Notes: _____

SPECIES: _____
Date: _____
Location:_____
Notes: _____

SPECIES: _____
Date: _____
Location:_____
Notes: _____

SPECIES: _____
Date: _____
Location:_____
Notes: _____

SPECIES: _____
Date: _____
Location:_____
Notes: _____

SPECIES: _____
Date: _____
Location:_____
Notes: _____

SPECIES: _____
Date: _____
Location:_____
Notes: _____

SPECIES: _____
Date: _____
Location:_____
Notes: _____

SPECIES: _____
Date: _____
Location:_____
Notes: _____

SPECIES: _____
Date: _____
Location:_____
Notes: _____

November Birding Trips

Location:_____ Location:_____
Date: _____ Date: _____

Location: _____

Date: _____

Seed Types

By varying the type of seed offered at your feeder you can attract different kinds of birds. Below is a list of seeds and the birds they attract.

Sunflower Seeds

Blackbirds	Juncos
Buntings	Nuthatches
Cardinals	Redpolls
Chickadees	Sparrows
Finches	Titmice
Grosbeaks	Towhees
Jays	Woodpeckers

Safflower Seeds

Cardinals	Nuthatches
Finches	Titmice
Grosbeaks	

Corn

Blackbirds	Jays
Catbirds	Juncos
Doves	Sparrows

Millet

Blackbirds	Doves
Finches	Sparrows

Thistle

Finches	Juncos

Peanuts

Cardinals	Finches
Chickadees	Jays
Doves	Juncos

Notes

"If men had wings and bore black feathers, few of them would be clever enough to be crows."

– Rev. Henry Ward Beecher

November

November

❄️ End-of-the-Month List

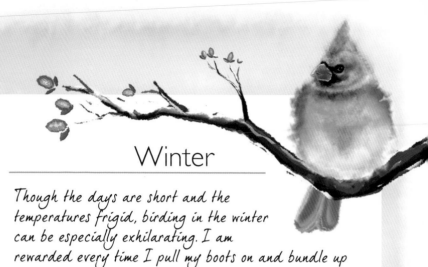

Winter

Though the days are short and the temperatures frigid, birding in the winter can be especially exhilarating. I am rewarded every time I pull my boots on and bundle up for a winter birding hike through the snow. The crisp winter air adds a clarity to the bird calls and the lack of leaves on the trees allows great viewing opportunities.

If braving the elements is not your cup of tea, then why not enjoy a little feeder birding from inside while holding a warm cup of tea? The scarcity of food and lack of resources often draws many species to feeders during the winter and allows for great looks at everything from goldfinches to nuthatches to woodpeckers.

❄

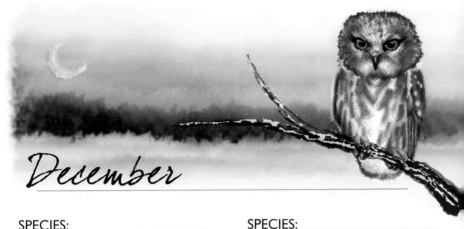

December

SPECIES: _____
Date: _____
Location: _____
Notes: _____

SPECIES: _____
Date: _____
Location: _____
Notes: _____

SPECIES: _____
Date: _____
Location: _____
Notes: _____

SPECIES: _____
Date: _____
Location: _____
Notes: _____

SPECIES: _____
Date: _____
Location: _____
Notes: _____

SPECIES: _____
Date: _____
Location: _____
Notes: _____

SPECIES: _____
Date: _____
Location: _____
Notes: _____

SPECIES: _____
Date: _____
Location: _____
Notes: _____

SPECIES: _____
Date: _____
Location: _____
Notes: _____

SPECIES: _____
Date: _____
Location: _____
Notes: _____

SPECIES: _____
Date: _____
Location: _____
Notes: _____

SPECIES: _____
Date: _____
Location: _____
Notes: _____

SPECIES: _____
Date: _____
Location: _____
Notes: _____

SPECIES: _____
Date: _____
Location: _____
Notes: _____

SPECIES: _____
Date: _____
Location: _____
Notes: _____

SPECIES: _____
Date: _____
Location: _____
Notes: _____

SPECIES: _____
Date: _____
Location: _____
Notes: _____

SPECIES: _____
Date: _____
Location: _____
Notes: _____

Feeder Birds Winter Checklist

COMMON

- ☐ American Goldfinch
- ☐ American Robin
- ☐ Carolina Wren
- ☐ Chickadees
- ☐ Brown-headed Cowbird
- ☐ Dark-eyed Junco
- ☐ Downy Woodpecker
- ☐ Eastern Towhee
- ☐ European Starling
- ☐ Hairy Woodpecker
- ☐ House Wren
- ☐ Jays
- ☐ Mourning Dove
- ☐ Northern Cardinal
- ☐ Northern Mockingbird
- ☐ Red-bellied Woodpecker
- ☐ Red-breasted Nuthatch
- ☐ Song Sparrow
- ☐ Tufted Titmouse
- ☐ White-breasted Nuthatch
- ☐ White-throated Sparrow

LESS COMMON

- ☐ Cedar Waxwing
- ☐ Common Redpoll
- ☐ Evening Grosbeak
- ☐ Painted Bunting
- ☐ Pine Siskin
- ☐ Purple Finch
- ☐ Red-headed Woodpecker

SPECIES: _____
Date: _____
Location: _____
Notes: _____

SPECIES: _____
Date: _____
Location: _____
Notes: _____

SPECIES: _____
Date: _____
Location: _____
Notes: _____

SPECIES: _____
Date: _____
Location: _____
Notes: _____

SPECIES: _____
Date: _____
Location: _____
Notes: _____

December

SPECIES: _____
Date: _____
Location:_____
Notes: _____

SPECIES: _____
Date: _____
Location:_____
Notes: _____

SPECIES: _____
Date: _____
Location:_____
Notes: _____

SPECIES: _____
Date: _____
Location:_____
Notes: _____

SPECIES: _____
Date: _____
Location:_____
Notes: _____

SPECIES: _____
Date: _____
Location:_____
Notes: _____

SPECIES: _____
Date: _____
Location:_____
Notes: _____

SPECIES: _____
Date: _____
Location:_____
Notes: _____

SPECIES: _____
Date: _____
Location:_____
Notes: _____

SPECIES: _____
Date: _____
Location:_____
Notes: _____

December Birding Trips

Location:_____ Location:_____
Date: _____ Date: _____

_____ _____
_____ _____
_____ _____
_____ _____
_____ _____
_____ _____
_____ _____
_____ _____
_____ _____
_____ _____
_____ _____
_____ _____
_____ _____
_____ _____
_____ _____
_____ _____
_____ _____
_____ _____
_____ _____
_____ _____
_____ _____
_____ _____
_____ _____
_____ _____
_____ _____
_____ _____
_____ _____
_____ _____

Bird Suet

Suet cakes provide a highly concentrated energy source that helps birds maintain their body temperature throughout the colder months. By making your own suet and varying the ingredients, you can attract different species. It's so much fun to mix it up and see who comes!

Note: If you add fruit to your suet it will attract woodpeckers, bluebirds, wrens, warblers & orioles!

Ideas for Suet Ingredients

- insects
- berries
- cereal
- seeds
- raisins
- currants
- oats
- cracked corn kernels
- apples (chopped)
- eggshells
- honey
- crushed pet food
- unsalted nuts

❄ Basic Suet Recipe

- 1 cup rendered suet, bulk tallow, lard, or bacon drippings *
- 1 cup chunky peanut butter
- 3 cups stone-ground cornmeal
- ½ cup white or whole-wheat flour

Melt the suet and peanut butter together until they are smooth and liquid. Add the cornmeal and flour, mixing well. Allow the mixture to cool slightly and then add any of the "extras" listed above. Pour into pan or muffin tins (cupcake liners make it easy to remove). Refrigerate or freeze suet until it is firm and you are ready to use it.

*Vegan alternative: Use vegetable shortening instead of animal fat

Notes

 "I don't ask for the meaning of the song of a bird or the rising of the sun on a misty morning. There they are, and they are beautiful."

—Pete Hamill

Notes

*** Holiday Wish List**

- New binoculars
- Hummingbird feeder
- BirdCam
- Birding journal
- Bluebird house
- Birdsong CDs
- New field guide
- Birdbath
- Platform feeder
- Spotting scope
- Lens pen
- Scope camera
- Bird calendar

❄ End-of-the-Month List

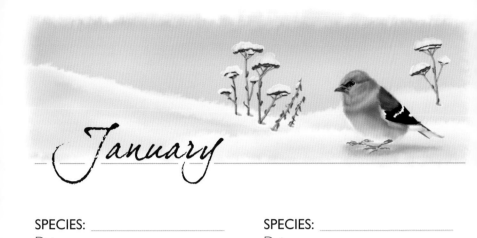

January

SPECIES: _____
Date: _____
Location: _____
Notes: _____

SPECIES: _____
Date: _____
Location: _____
Notes: _____

SPECIES: _____
Date: _____
Location: _____
Notes: _____

SPECIES: _____
Date: _____
Location: _____
Notes: _____

SPECIES: _____
Date: _____
Location: _____
Notes: _____

SPECIES: _____
Date: _____
Location: _____
Notes: _____

SPECIES: _____
Date: _____
Location: _____
Notes: _____

SPECIES: _____
Date: _____
Location: _____
Notes: _____

SPECIES: _____
Date: _____
Location:_____
Notes: _____

SPECIES: _____
Date: _____
Location:_____
Notes: _____

SPECIES: _____
Date: _____
Location:_____
Notes: _____

SPECIES: _____
Date: _____
Location:_____
Notes: _____

SPECIES: _____
Date: _____
Location:_____
Notes: _____

SPECIES: _____
Date: _____
Location:_____
Notes: _____

SPECIES: _____
Date: _____
Location:_____
Notes: _____

SPECIES: _____
Date: _____
Location:_____
Notes: _____

SPECIES: _____
Date: _____
Location:_____
Notes: _____

SPECIES: _____
Date: _____
Location:_____
Notes: _____

SPECIES: _____
Date: _____
Location: _____
Notes: _____

SPECIES: _____
Date: _____
Location: _____
Notes: _____

SPECIES: _____
Date: _____
Location: _____
Notes: _____

SPECIES: _____
Date: _____
Location: _____
Notes: _____

SPECIES: _____
Date: _____
Location: _____
Notes: _____

SPECIES: _____
Date: _____
Location: _____
Notes: _____

Winter Birding Checklist & Tips

- ☐ Waterproof binoculars
- ☐ Sunglasses
- ☐ Waterproof boots
- ☐ Sunscreen
- ☐ Camera
- ☐ Hand warmers
- ☐ Plastic bags
- ☐ Skis/Snowshoes

- ☐ Field guide
- ☐ Water bottle & snack
- ☐ Layered clothing
- ☐ Current weather & road reports
- ☐ Full tank of gas
- ☐ Bright piece of cloth to signal emergency

January

SPECIES: _____
Date: _____
Location:_____
Notes: _____

SPECIES: _____
Date: _____
Location:_____
Notes: _____

SPECIES: _____
Date: _____
Location:_____
Notes: _____

SPECIES: _____
Date: _____
Location:_____
Notes: _____

SPECIES: _____
Date: _____
Location:_____
Notes: _____

SPECIES: _____
Date: _____
Location:_____
Notes: _____

SPECIES: _____
Date: _____
Location:_____
Notes: _____

SPECIES: _____
Date: _____
Location:_____
Notes: _____

SPECIES: _____
Date: _____
Location:_____
Notes: _____

SPECIES: _____
Date: _____
Location:_____
Notes: _____

January Birding Trips

Location: _____ Location: _____
Date: _____ Date: _____

_____ _____
_____ _____
_____ _____
_____ _____
_____ _____
_____ _____
_____ _____
_____ _____
_____ _____
_____ _____
_____ _____
_____ _____
_____ _____
_____ _____
_____ _____
_____ _____
_____ _____
_____ _____
_____ _____
_____ _____
_____ _____
_____ _____
_____ _____
_____ _____
_____ _____
_____ _____

Location: _____

Date: _____

Berries for Birds

When landscaping your yard, try to use a combination of plants that produce food throughout the year. Below is a list of trees, shrubs and vines that retain their fruit into the winter.

Trees & Shrubs
Ash
Barberry
Bayberry
Beautyberry
Chokeberry
Crabapple
Dogwood
Eastern Red Cedar
Elderberry
Hackberry
Hawthorns
Holly
Pyracantha
Roses
Serviceberry
Spicebush
Sumac
Viburnum
Winterberry

Vines
American Bittersweet
Grapes
Greenbriar

Notes

January

Notes

"Hear! hear!" screamed the jay from a neighboring tree, where I had heard a tittering for some time, "Winter has a concentrated and nutty kernel, if you know where to look for it."

— Henry David Thoreau

January

❄ End-of-the-Month List

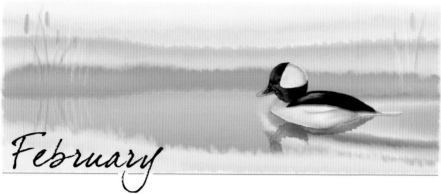

February

SPECIES: _____
Date: _____
Location: _____
Notes: _____

SPECIES: _____
Date: _____
Location: _____
Notes: _____

SPECIES: _____
Date: _____
Location: _____
Notes: _____

SPECIES: _____
Date: _____
Location: _____
Notes: _____

SPECIES: _____
Date: _____
Location: _____
Notes: _____

SPECIES: _____
Date: _____
Location: _____
Notes: _____

SPECIES: _____
Date: _____
Location: _____
Notes: _____

SPECIES: _____
Date: _____
Location: _____
Notes: _____

SPECIES: _____
Date: _____
Location: _____
Notes: _____

SPECIES: _____
Date: _____
Location: _____
Notes: _____

SPECIES: _____
Date: _____
Location: _____
Notes: _____

SPECIES: _____
Date: _____
Location: _____
Notes: _____

SPECIES: _____
Date: _____
Location: _____
Notes: _____

SPECIES: _____
Date: _____
Location: _____
Notes: _____

SPECIES: _____
Date: _____
Location: _____
Notes: _____

SPECIES: _____
Date: _____
Location: _____
Notes: _____

SPECIES: _____
Date: _____
Location: _____
Notes: _____

SPECIES: _____
Date: _____
Location: _____
Notes: _____

❄ Winter Waterfowl Checklist

- ☐ American Black Duck
- ☐ American Coot
- ☐ American Wigeon
- ☐ Blue-winged Teal
- ☐ Brant
- ☐ Bufflehead
- ☐ Canada Goose
- ☐ Canvasback
- ☐ Common Gallinule
- ☐ Common Goldeneye
- ☐ Common Loon
- ☐ Common Merganser
- ☐ Gadwall
- ☐ Greater Scaup
- ☐ Green-winged Teal
- ☐ Harlequin Duck
- ☐ Hooded Merganser
- ☐ Lesser Scaup
- ☐ Long-tailed Duck
- ☐ Mallard
- ☐ Mute Swan
- ☐ Northern Pintail
- ☐ Northern Shoveler
- ☐ Pied-billed Grebe
- ☐ Purple Gallinule
- ☐ Red-breasted Merganser
- ☐ Redhead
- ☐ Ring-necked Duck
- ☐ Ross's Goose
- ☐ Ruddy Duck
- ☐ Scoters
- ☐ Snow/Blue Goose
- ☐ Trumpeter Swan
- ☐ Tundra Swan
- ☐ Whistling Duck
- ☐ White-fronted Goose
- ☐ Wood Duck

SPECIES: _____
Date: _____
Location:_____
Notes: _____

SPECIES: _____
Date: _____
Location:_____
Notes: _____

SPECIES: _____
Date: _____
Location:_____
Notes: _____

SPECIES: _____
Date: _____
Location:_____
Notes: _____

SPECIES: _____
Date: _____
Location:_____
Notes: _____

February

SPECIES: _____
Date: _____
Location:_____
Notes: _____

SPECIES: _____
Date: _____
Location:_____
Notes: _____

SPECIES: _____
Date: _____
Location:_____
Notes: _____

SPECIES: _____
Date: _____
Location:_____
Notes: _____

SPECIES: _____
Date: _____
Location:_____
Notes: _____

SPECIES: _____
Date: _____
Location:_____
Notes: _____

SPECIES: _____
Date: _____
Location:_____
Notes: _____

SPECIES: _____
Date: _____
Location:_____
Notes: _____

SPECIES: _____
Date: _____
Location:_____
Notes: _____

SPECIES: _____
Date: _____
Location:_____
Notes: _____

February Birding Trips

Location: _____ Location: _____
Date: _____ Date: _____

_____ _____
_____ _____
_____ _____
_____ _____
_____ _____
_____ _____
_____ _____
_____ _____
_____ _____
_____ _____
_____ _____
_____ _____
_____ _____
_____ _____
_____ _____
_____ _____
_____ _____
_____ _____
_____ _____
_____ _____
_____ _____
_____ _____
_____ _____
_____ _____
_____ _____
_____ _____
_____ _____
_____ _____

Location:_____

Date: _____

❄ Winter Birding Getaways

Aransas National Wildlife Refuge (Austwell, TX)

Rio Grande Valley Bird Observatory (Brownsville, TX)

Everglades National Park (Homestead, FL)

Chiricahua National Monument (Willcox, AZ)

Joshua Tree National Park (Twentynine Palms, CA)

Bosque del Apache National Wildlife Refuge (San Antonio, NM)

Rockport/Fulton, TX

Mattamuskeet National Wildlife Refuge (Swan Quarter, NC)

Santa Ana National Wildlife Refuge (Pharr, TX)

Okefenokee Swamp (Folkston, GA)

Salton Sea State Park (Niland, CA)

Notes

February

Notes

"In the depth of winter I finally learned that there was in me an invincible summer." *— Albert Camus*

February

❄ End-of-the-Month List

From Year to Year

Year: _2008_

SPECIES: _Loon_

Notes: _Saw first loons of the year_ — April 15
Loon on nest — May 2
Chicks hatched and swimming! — June 12
Chicks riding on mom's back — June 15 – 2 chicks with parents!
Last loon sighting — October 22

Year: _____

SPECIES: _____
Notes: _____

SPECIES: _____
Notes: _____

SPECIES: _____
Notes: _____

Year: **2009**

April 20
May 8
June 16
June 16 – 1 chick swimming w/ mom
October 10

Year: **2010**

April 5
May 10 – same nest!
June 14
June 17 – 2 chicks w/ mom
~~October 2~~ October 8

Year:

Year:

From Year to Year

Year: _____

SPECIES: _____

Notes: _____

SPECIES: _____

Notes: _____

SPECIES: _____

Notes: _____

SPECIES: _____

Notes: _____

"It may be hard for an egg to turn into a bird: it would be a jolly sight harder for it to learn to fly while remaining an egg. We are like

Year:_____ Year:_____

eggs at present. And you cannot go on indefinitely being just an ordinary, decent egg. We must be hatched or go bad." -C.S. Lewis

From Year to Year

Year: _____

SPECIES: _____

Notes: _____

SPECIES: _____

Notes: _____

SPECIES: _____

Notes: _____

SPECIES: _____

Notes: _____

Year:_____ Year:_____

"And when is there time to remember, to sift, to weigh,
to estimate, to total?" -Tillie Olsen

From Year to Year

Year:_____

SPECIES: _____

Notes: _____

SPECIES: _____

Notes: _____

SPECIES: _____

Notes: _____

SPECIES: _____

Notes: _____

*"Action and reaction, ebb and flow, trial and error, change
—this is the rhythm of living."* *—Bruce Barton*

Year:_____

Year:_____

Key to Bird Illustrations

Spring - *Male & Female American Redstarts, pg. 7*
March - *Red-breasted Nuthatch. pg. 8*
Bird Houses - *Purple Martin, pg. 13*
April - *Ruby-crowned Kinglet, pg. 18*
May - *Common Yellowthroat, pg. 28*
Nest Types - *Baltimore Oriole, pg. 33*

Summer - *Eastern Meadowlark, pg. 39*
June - *Rose-breasted Grosbeak, pg. 40*
Chick Development - *Carolina Chickadee, pg. 45*
July - *Black-crowned Night Heron, pg. 50*
Attract Hummingbirds - *Ruby-throated Hummingbird, pg. 53*
Birding by Boat - *Northern Gannet, pg. 55*
August - *Black Skimmer, pg. 60*
Molting - *Scarlet Tanager, pg. 65*

Fall - *Blue Jay, pg. 71*
September - *Pileated Woodpecker, pg. 72*
October - *Osprey, pg. 82*
Sites for Hawk-watching - *Sharp-shinned Hawk, pg. 87*
November - *Sandhill Crane, pg. 92*
Migration Distance - *Arctic Tern, pg. 94*

Winter - *Male & Female Northern Cardinals, pg. 101*
December - *Northern Saw-whet Owl, pg. 102*
Bird Suet - *Downy Woodpecker, pg. 107*
January - *American Goldfinch, pg. 112*
February - *Bufflehead, pg. 122*
Winter Birding Getaways - *Purple Gallinule, pg. 127*

Key to Plant Illustrations

Spring
March - *Bloodroot, pg. 15*
April - *Grape Hyacinth, pg. 24*
May - *Columbine, pg. 34*

Summer
June - *Squash Blossom, pg. 46*
July - *Dandelion, pg. 57*
August - *Thistle. pg. 66*

Fall
September - *Milkweed Pod, pg. 79*
October - *Sassafras, pg. 88*
November - *Osage Orange. pg. 99*

Winter
December - *Holly, pg. 108*
January - *Sweetgum, pg. 118*
February - *Pine, pg. 128*

Birding Life List

- [] Albatross, Black-footed
- [] Anhinga
- [] Ani, Groove-billed
- [] Ani, Smooth-billed
- [] Auklet, Rhinoceros
- [] Auklet, _____
- [] Avocet, American
- [] Bittern, American
- [] Bittern, Least
- [] Blackbird, Brewer's
- [] Blackbird, Red-winged
- [] Blackbird, Rusty
- [] Blackbird, Yellow-headed
- [] Bluebird, Eastern
- [] Bluebird, Mountain
- [] Bluebird, Western
- [] Bobolink
- [] Bobwhite, Northern
- [] Booby, Brown
- [] Brant
- [] Bufflehead
- [] Bunting, Indigo
- [] Bunting, Lazuli
- [] Bunting, _____
- [] Bunting, _____
- [] Bushtit
- [] Canvasback
- [] Caracara, Crested
- [] Cardinal, Northern
- [] Catbird, Gray
- [] Chachalaca, Plain
- [] Chat, Yellow-breasted
- [] Chickadee, Black-capped
- [] Chickadee, Boreal
- [] Chickadee, Carolina
- [] Chickadee, Chestnut-backed
- [] Chickadee, Mountain
- [] Chuck-will's-widow

- [] Condor, California
- [] Coot, American
- [] Cormorant, Brandt's
- [] Cormorant, Double-crested
- [] Cormorant, Great
- [] Cormorant, Neotropic
- [] Cormorant, Pelagic
- [] Cowbird, Bronzed
- [] Cowbird, Brown-headed
- [] Crane, Sandhill
- [] Crane, Whooping
- [] Creeper, Brown
- [] Crossbill, Red
- [] Crossbill, White-winged
- [] Crow, American
- [] Crow, Fish
- [] Crow, Northwestern
- [] Cuckoo, Black-billed
- [] Cuckoo, Yellow-billed
- [] Curlew, Long-billed
- [] Dickcissel
- [] Dipper, American
- [] Dove, Inca
- [] Dove, Mourning
- [] Dove, White-winged
- [] Dove, _____
- [] Dovekie
- [] Dowitcher, Long-billed
- [] Dowitcher, Short-billed
- [] Duck, American Black
- [] Duck, Ring-necked
- [] Duck, Ruddy
- [] Duck, Wood
- [] Duck, _____
- [] Dunlin
- [] Eagle, Bald
- [] Eagle, Golden
- [] Egret, Cattle

Birding Life List

- [] Egret, Great
- [] Egret, Reddish
- [] Egret, Snowy
- [] Eider, Common
- [] Eider, King
- [] Falcon, Aplomado
- [] Falcon, Peregrine
- [] Falcon, Prairie
- [] Finch, Cassin's
- [] Finch, House
- [] Finch, Purple
- [] Flamingo, American
- [] Flicker, Northern
- [] Flycatcher, Acadian
- [] Flycatcher, Alder
- [] Flycatcher, Great Crested
- [] Flycatcher, Least
- [] Flycatcher, Olive-sided
- [] Flycatcher, Scissor-tailed
- [] Flycatcher, Vermilion
- [] Flycatcher, Willow
- [] Flycatcher, _____
- [] Flycatcher, _____
- [] Frigatebird, Magnificent
- [] Fulmar, Northern
- [] Gadwall
- [] Gallinule, Purple
- [] Gannet, Northern
- [] Gnatcatcher, Black-tailed
- [] Gnatcatcher, Blue-gray
- [] Godwit, Marbled
- [] Goldeneye, Barrow's
- [] Goldeneye, Common
- [] Goldfinch, American
- [] Goldfinch, Lawrence's
- [] Goldfinch, Lesser
- [] Goose, Canada
- [] Goose, Greater White-fronted

- [] Goose, Ross's
- [] Goose, Snow
- [] Goshawk, Northern
- [] Grackle, Boat-tailed
- [] Grackle, Common
- [] Grackle, Great-tailed
- [] Grebe, Clark's
- [] Grebe, Horned
- [] Grebe, Pied-billed
- [] Grebe, Western
- [] Grebe, _____
- [] Grosbeak, Black-headed
- [] Grosbeak, Blue
- [] Grosbeak, Evening
- [] Grosbeak, Pine
- [] Grosbeak, Rose-breasted
- [] Ground-Dove, Common
- [] Ground-Dove, Ruddy
- [] Grouse, Ruffed
- [] Grouse, Sharp-tailed
- [] Grouse, Spruce
- [] Grouse, _____
- [] Guillemot, Black
- [] Guillemot, Pigeon
- [] Gull, Bonaparte's
- [] Gull, California
- [] Gull, Glaucous-winged
- [] Gull, Great Black-backed
- [] Gull, Heermann's
- [] Gull, Herring
- [] Gull, Laughing
- [] Gull, Ring-billed
- [] Gull, Western
- [] Gull, _____
- [] Gyrfalcon
- [] Harrier, Northern
- [] Hawk, Broad-winged
- [] Hawk, Cooper's

Birding Life List

- [] Hawk, Ferruginous
- [] Hawk, Red-shouldered
- [] Hawk, Red-tailed
- [] Hawk, Rough-legged
- [] Hawk, Sharp-shinned
- [] Hawk, Swainson's
- [] Hawk, _____
- [] Heron, Great Blue
- [] Heron, Green
- [] Heron, Little Blue
- [] Heron, Tricolored
- [] Hummingbird, Allen's
- [] Hummingbird, Anna's
- [] Hummingbird, Black-chinned
- [] Hummingbird, Broad-tailed
- [] Hummingbird, Calliope
- [] Hummingbird, Costa's
- [] Hummingbird, Ruby-throated
- [] Hummingbird, Rufous
- [] Hummingbird, _____
- [] Ibis, Glossy
- [] Ibis, White
- [] Ibis, _____
- [] Jaeger, _____
- [] Jay, Blue
- [] Jay, Gray
- [] Jay, Steller's
- [] Jay, _____
- [] Junco, Dark-eyed
- [] Junco, Yellow-eyed
- [] Kestrel, American
- [] Killdeer
- [] Kingbird, Eastern
- [] Kingbird, Western
- [] Kingbird, _____
- [] Kingfisher, Belted
- [] Kinglet, Golden-crowned
- [] Kinglet, Ruby-crowned

- [] Kite, Mississippi
- [] Kite, _____
- [] Kittiwake, Black-legged
- [] Knot, Red
- [] Lark, Horned
- [] Limpkin
- [] Longspur, Chestnut-collared
- [] Longspur, Lapland
- [] Longspur, _____
- [] Loon, Common
- [] Loon, Red-throated
- [] Loon, _____
- [] Magpie, Black-billed
- [] Magpie, Yellow-billed
- [] Mallard
- [] Martin, Purple
- [] Meadowlark, Eastern
- [] Meadowlark, Western
- [] Merganser, Common
- [] Merganser, Hooded
- [] Merganser, Red-breasted
- [] Merlin
- [] Mockingbird, Northern
- [] Moorhen, Common
- [] Murre, Common
- [] Murre, Thick-billed
- [] Murrelet, Ancient
- [] Murrelet, Marbled
- [] Nighthawk, Common
- [] Nighthawk, Lesser
- [] Night-Heron, Black-crowned
- [] Night-Heron, Yellow-crowned
- [] Nutcracker, Clark's
- [] Nuthatch, Brown-headed
- [] Nuthatch, Pygmy
- [] Nuthatch, Red-breasted
- [] Nuthatch, White-breasted
- [] Oriole, Baltimore

Birding Life List

- [] Oriole, Bullock's
- [] Oriole, Orchard
- [] Oriole, _____
- [] Osprey
- [] Ovenbird
- [] Owl, Barred
- [] Owl, Burrowing
- [] Owl, Great Horned
- [] Owl, _____
- [] Owl, _____
- [] Oystercatcher, American
- [] Oystercatcher, Black
- [] Parula, Northern
- [] Pelican, American White
- [] Pelican, Brown
- [] Petrel, _____
- [] Phainopepla
- [] Phalarope, Wilson's
- [] Phalarope, _____
- [] Pheasant, Ring-necked
- [] Phoebe, Black
- [] Phoebe, Eastern
- [] Phoebe, Say's
- [] Pigeon, Band-tailed
- [] Pigeon, Rock
- [] Pintail, Northern
- [] Pipit, American
- [] Pipit, Sprague's
- [] Plover, Black-bellied
- [] Plover, Piping
- [] Plover, Semipalmated
- [] Plover, Snowy
- [] Plover, Wilson's
- [] Prairie-Chicken, Greater
- [] Prairie-Chicken, Lesser
- [] Puffin, Atlantic
- [] Puffin, Horned
- [] Puffin, Tufted

- [] Pygmy-Owl, Northern
- [] Pyrrhuloxia
- [] Quail, California
- [] Quail, Gambel's
- [] Quail, Montezuma
- [] Quail, Mountain
- [] Quail, Scaled
- [] Rail, Clapper
- [] Rail, King
- [] Rail, Virginia
- [] Rail, _____
- [] Raven, Chihuahuan
- [] Raven, Common
- [] Razorbill
- [] Redhead
- [] Redpoll, Common
- [] Redpoll, Hoary
- [] Redstart, American
- [] Redstart, Painted
- [] Roadrunner, Greater
- [] Robin, American
- [] Rosy-Finch, Gray-crowned
- [] Rosy-Finch, _____
- [] Sanderling
- [] Sandpiper, Least
- [] Sandpiper, Pectoral
- [] Sandpiper, Semipalmated
- [] Sandpiper, Solitary
- [] Sandpiper, Spotted
- [] Sandpiper, Western
- [] Sandpiper, _____
- [] Sandpiper, _____
- [] Sapsucker, Red-breasted
- [] Sapsucker, Red-naped
- [] Sapsucker, Williamson's
- [] Sapsucker, Yellow-bellied
- [] Scaup, Greater
- [] Scaup, Lesser

Birding Life List

- [] Scoter, Black
- [] Scoter, Surf
- [] Scoter, White-winged
- [] Screech-Owl, Eastern
- [] Screech-Owl, Western
- [] Scrub-Jay, Florida
- [] Scrub-Jay, Western
- [] Shearwater, Cory's
- [] Shoveler, Northern
- [] Shrike, Loggerhead
- [] Shrike, Northern
- [] Siskin, Pine
- [] Skimmer, Black
- [] Snipe, Wilson's
- [] Solitaire, Townsend's
- [] Sora
- [] Sparrow, Chipping
- [] Sparrow, Field
- [] Sparrow, Golden-crowned
- [] Sparrow, House
- [] Sparrow, Song
- [] Sparrow, Swamp
- [] Sparrow, White-crowned
- [] Sparrow, White-throated
- [] Sparrow, _____
- [] Sparrow, _____
- [] Spoonbill, Roseate
- [] Starling, European
- [] Stilt, Black-necked
- [] Stork, Wood
- [] Surfbird
- [] Swallow, Barn
- [] Swallow, Northern Rough-winged
- [] Swallow, Tree
- [] Swallow, Violet-green
- [] Swallow, _____
- [] Swan, Mute
- [] Swan, _____
- [] Swift, Black

- [] Swift, Chimney
- [] Swift, Vaux's
- [] Swift, White-throated
- [] Tanager, Scarlet
- [] Tanager, Summer
- [] Tanager, Western
- [] Tanager, _____
- [] Tattler, Wandering
- [] Teal, Blue-winged
- [] Teal, Cinnamon
- [] Teal, Green-winged
- [] Tern, Arctic
- [] Tern, Caspian
- [] Tern, Common
- [] Tern, Forster's
- [] Tern, Least
- [] Tern, Royal
- [] Tern, Sandwich
- [] Tern, _____
- [] Tern, _____
- [] Thrasher, Brown
- [] Thrasher, Sage
- [] Thrasher, _____
- [] Thrasher, _____
- [] Thrush, Hermit
- [] Thrush, Swainson's
- [] Thrush, Wood
- [] Thrush, _____
- [] Thrush, _____
- [] Titmouse, Tufted
- [] Titmouse, _____
- [] Towhee, Eastern
- [] Towhee, Green-tailed
- [] Towhee, Spotted
- [] Towhee, _____
- [] Towhee, _____
- [] Turkey, Wild
- [] Turnstone, Black
- [] Turnstone, Ruddy